Paisley

COLORING BOOK

Kelly A. Baker, Robin J. Baker
and Marty Noble

DOVER PUBLICATIONS, INC.
MINEOLA, NEW YORK

Copyright

Bibliographical Note

Paisley Coloring Book: Your Passport to Calm is a new work, first published by
Dover Publications, Inc., in 2016.

International Standard Book Number
ISBN-13: 978-0-486-81073-7
ISBN-10: 0-486-81073-9

Manufactured in the United States by RR Donnelley
81073901 2016
www.doverpublications.com

bliss

\ˈblis\

noun

1. supreme happiness; utter joy or contentment

2. heaven; paradise

3. your passport to calm

Take a pleasant journey into a world of relaxation with *BLISS Paisley Coloring Book: Your Passport to Calm*. The book features 46 ready-to-color illustrations of the timeless, tear-shaped motif, repeated within a variety of pretty floral and leaf images, abstract patterns, and mesmerizing designs. Now you can travel to your newly found retreat of peace and serenity whenever you'd like with this petite-sized collection of sophisticated artwork.

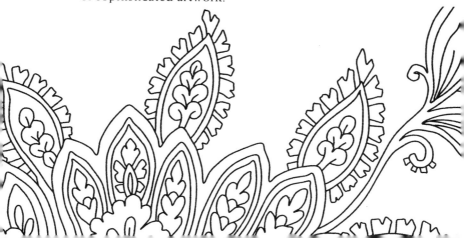

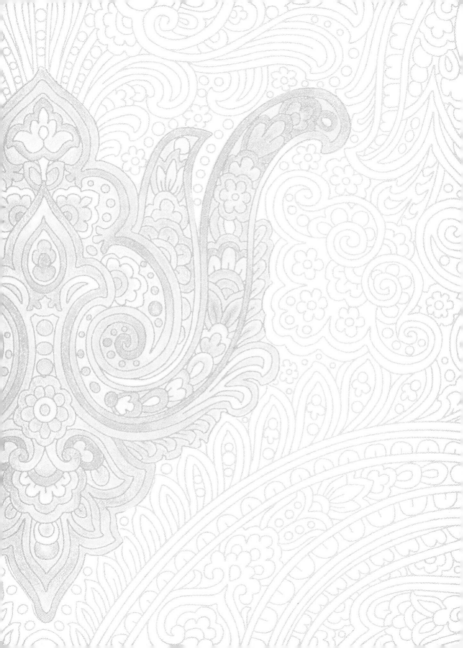

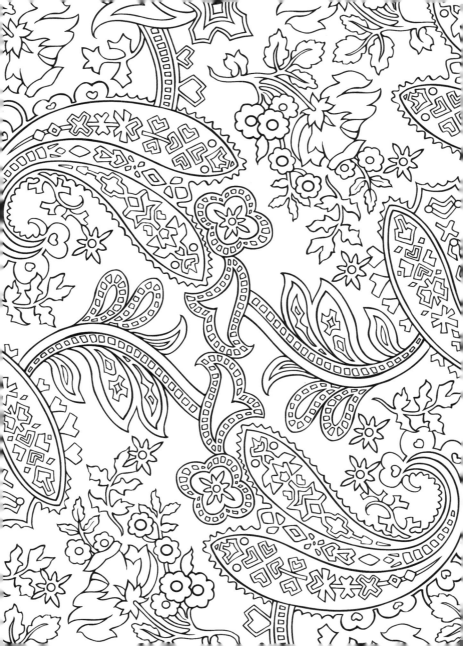

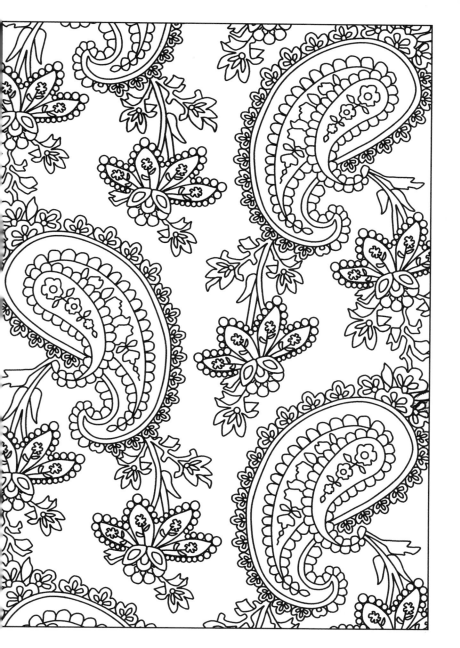

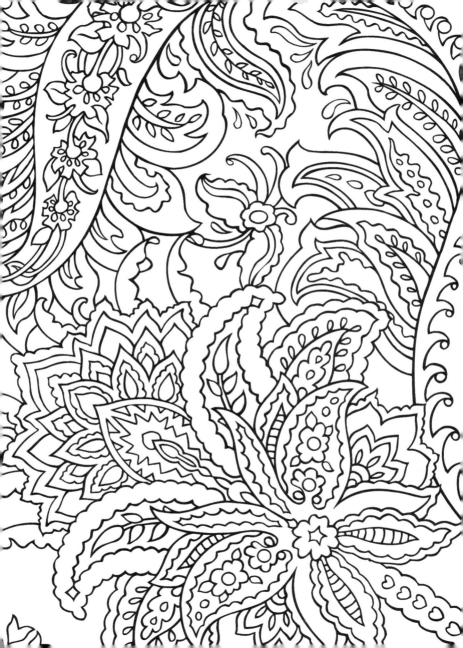

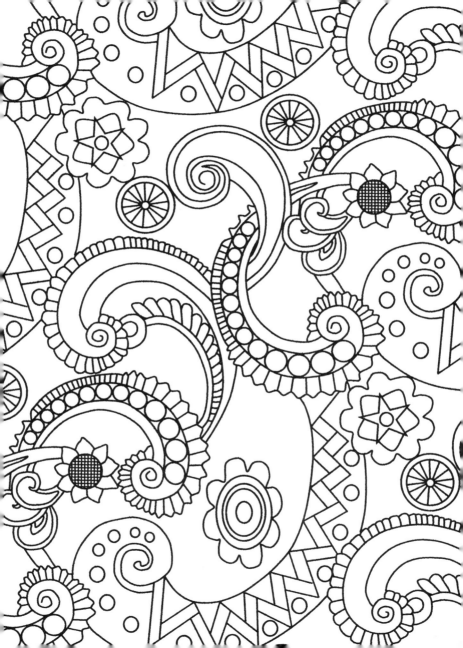

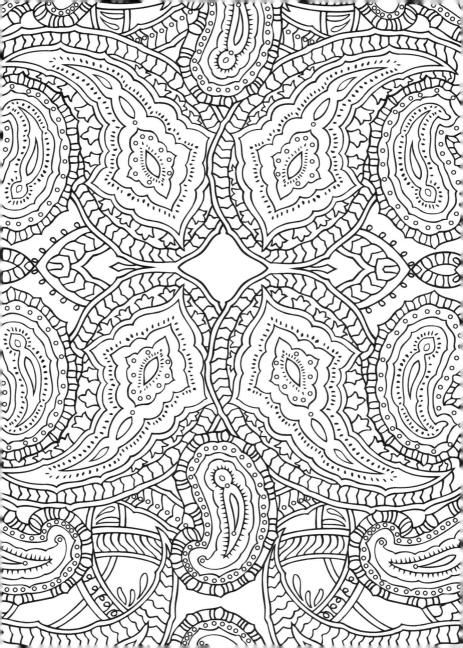

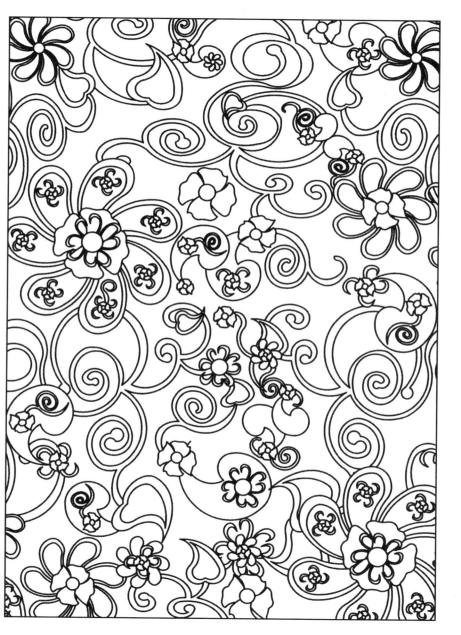

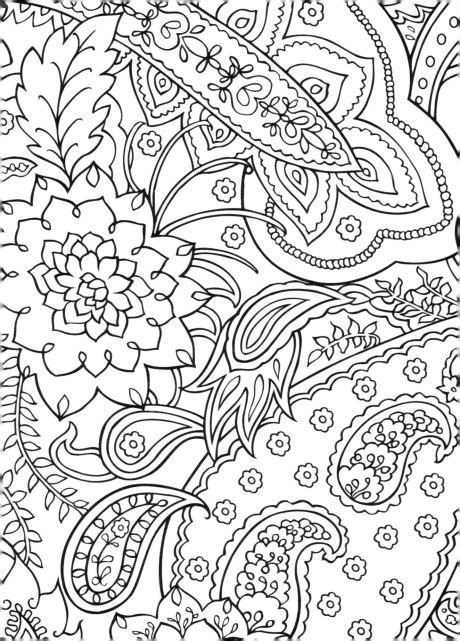

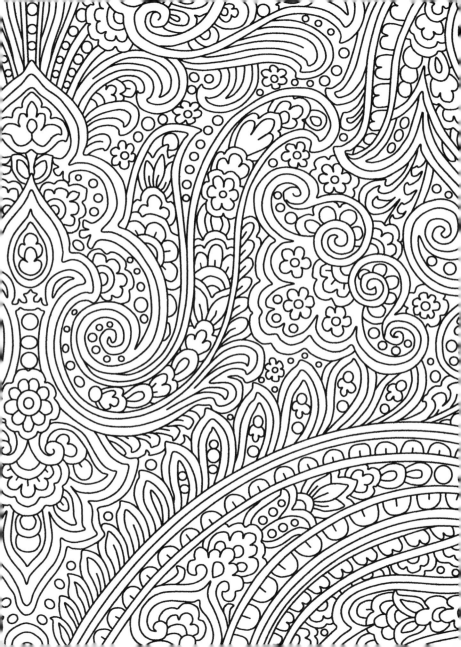

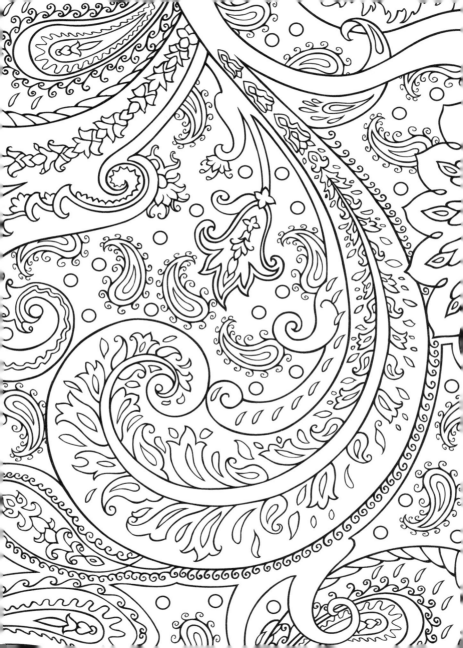

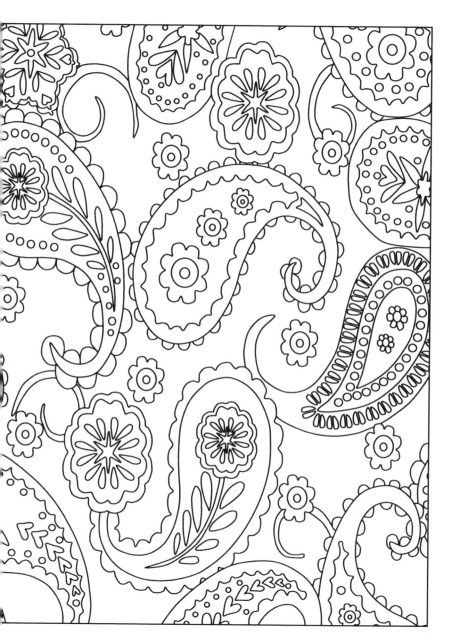

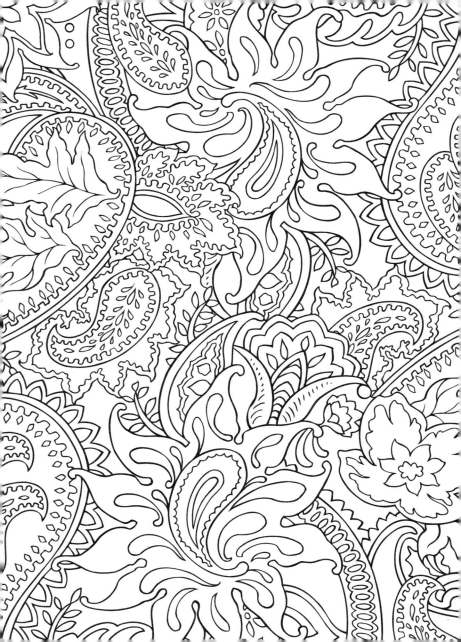

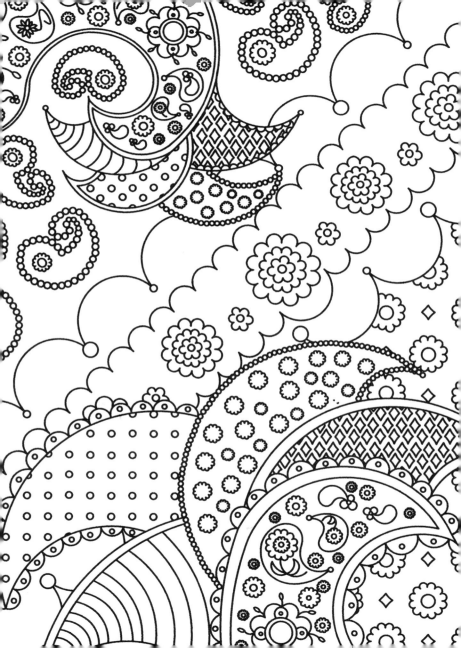

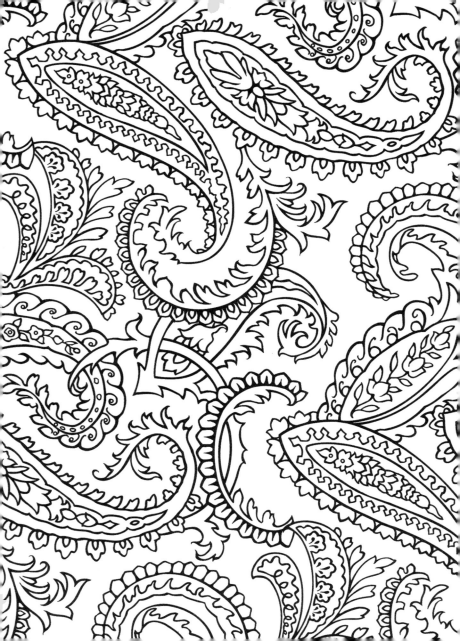

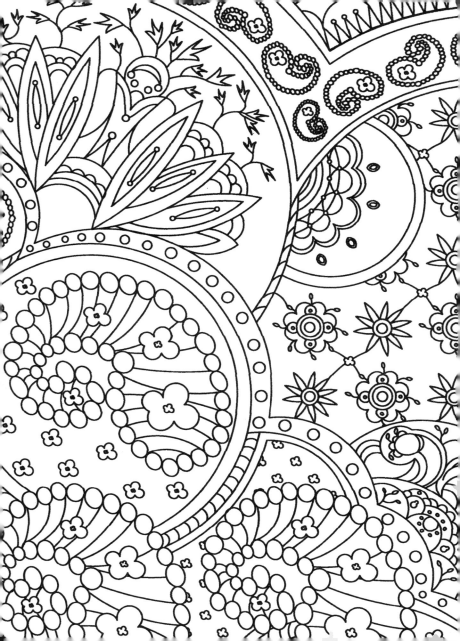

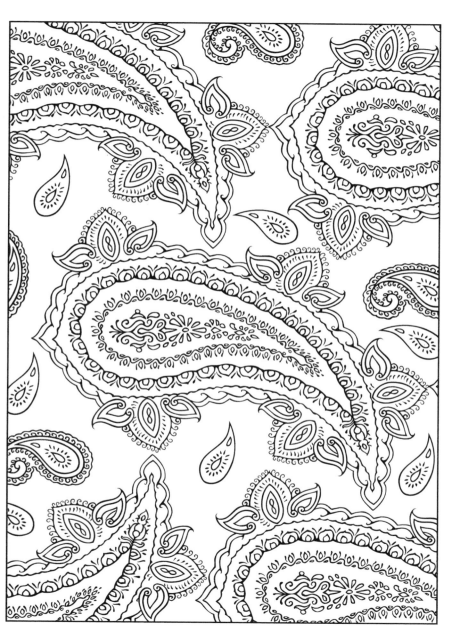

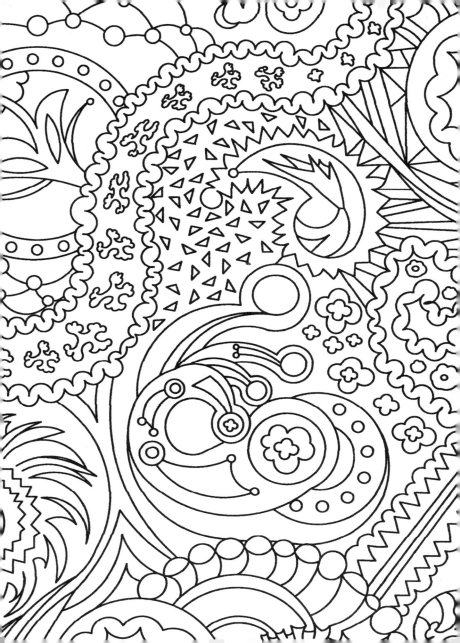

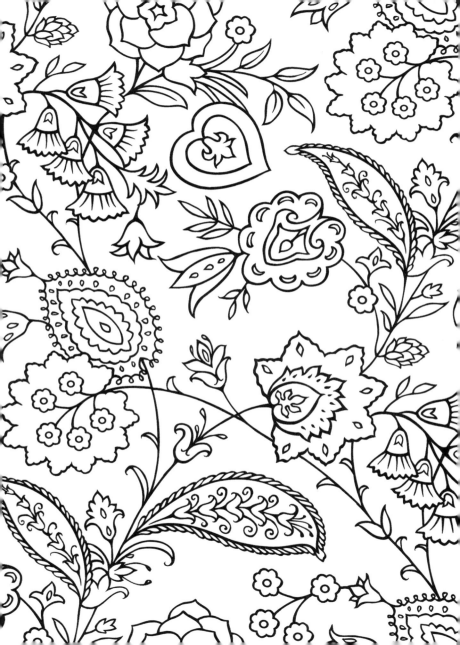

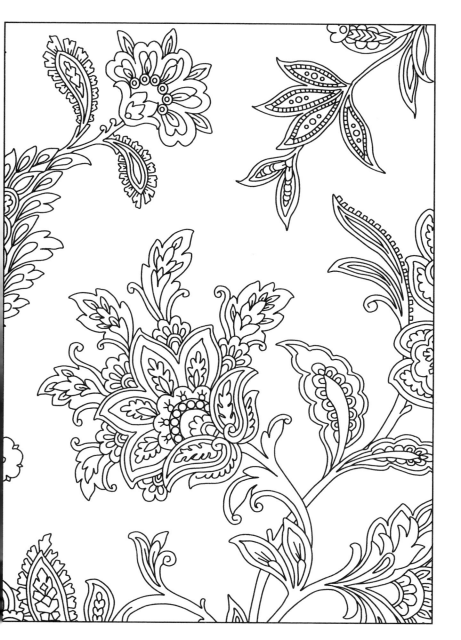

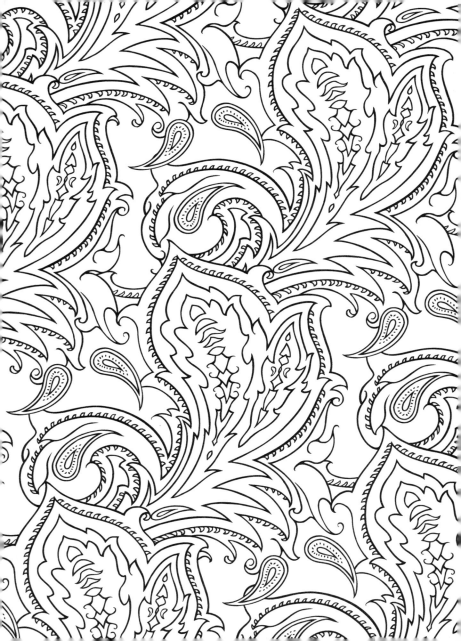

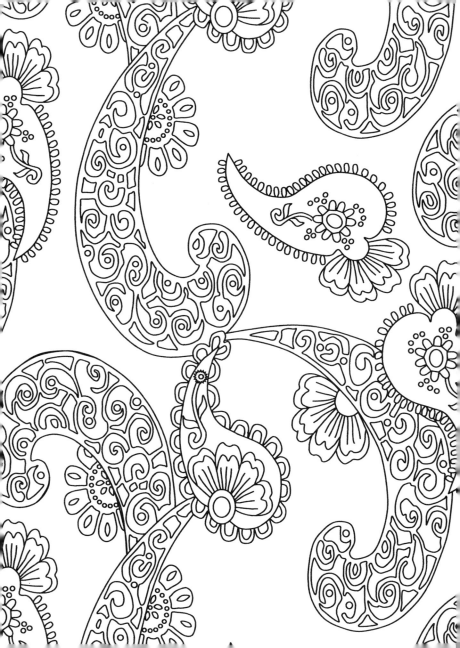

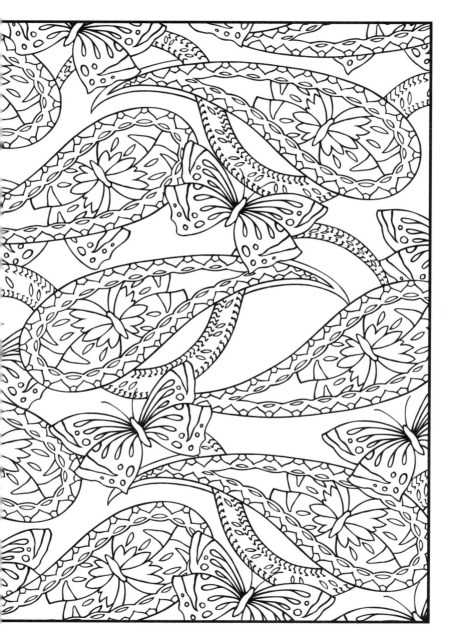

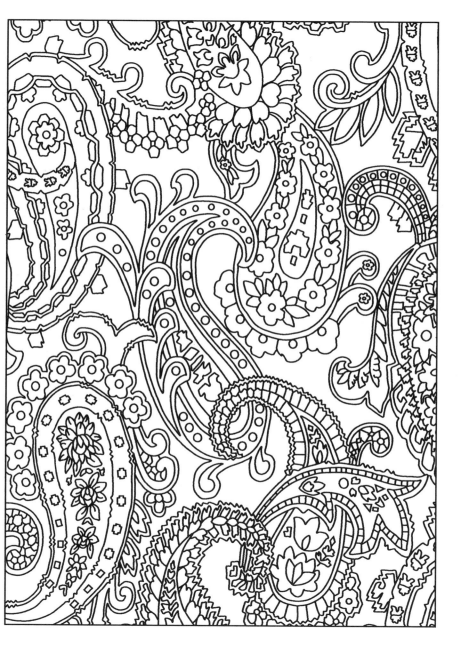

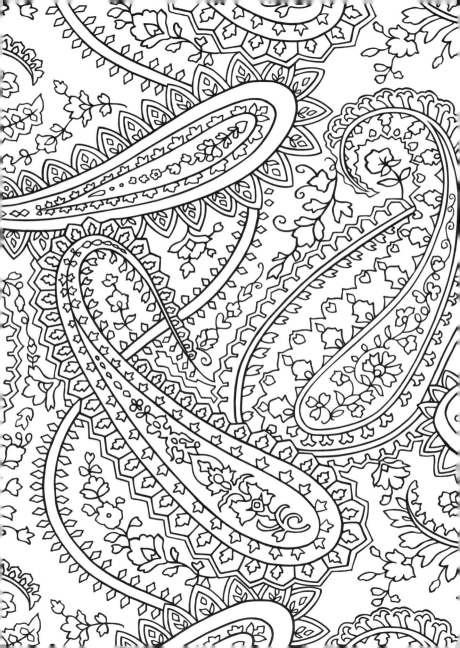

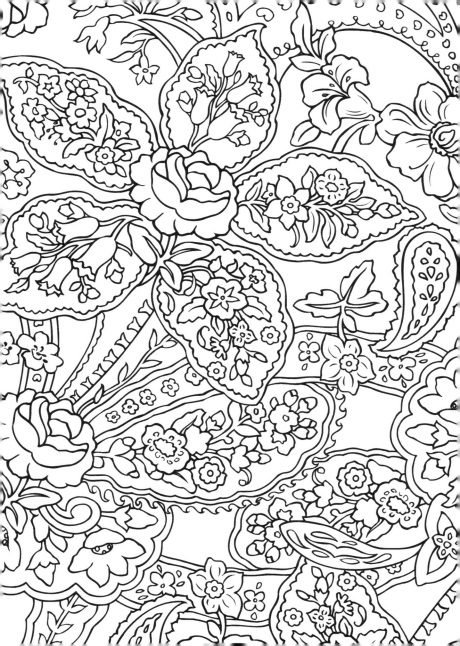

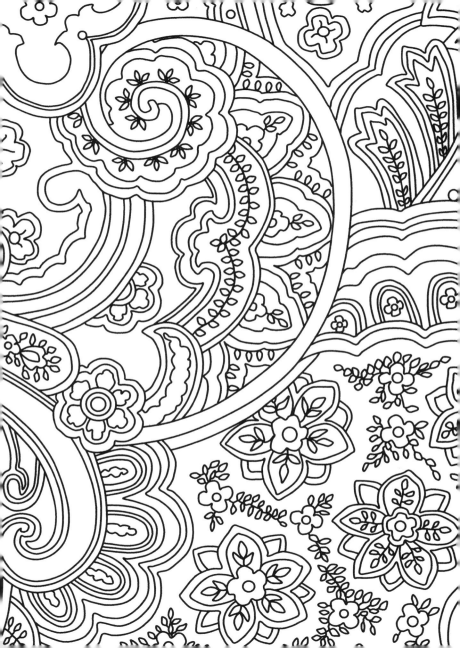

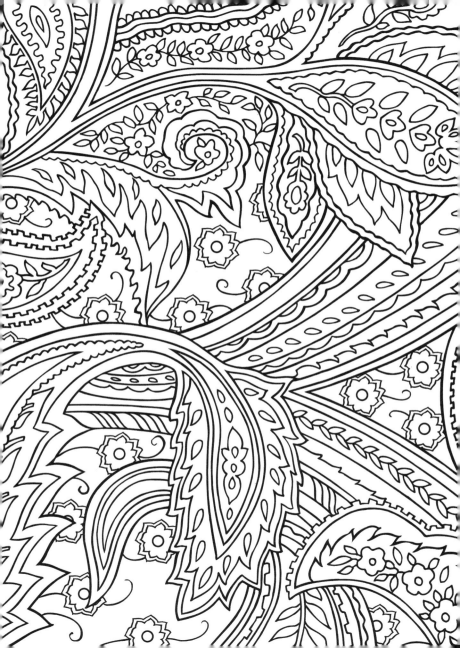

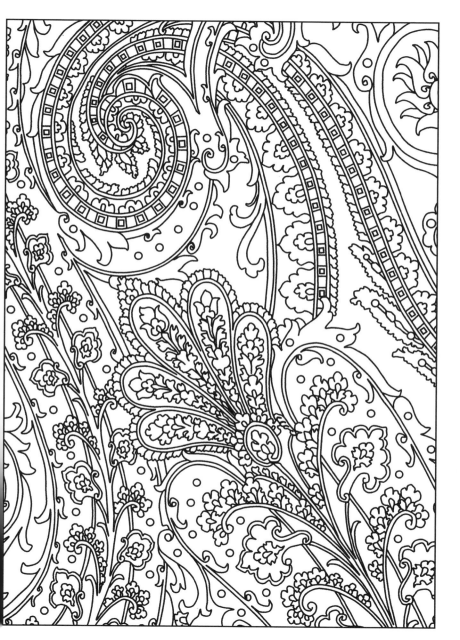

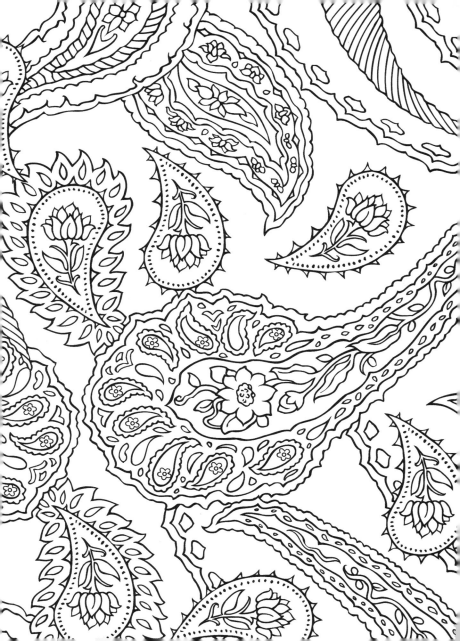

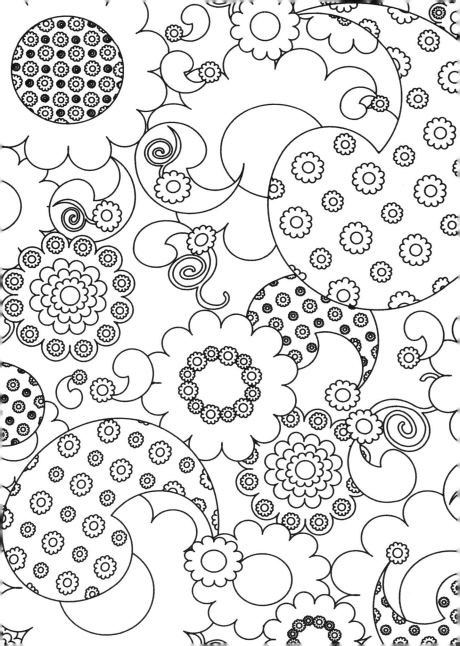

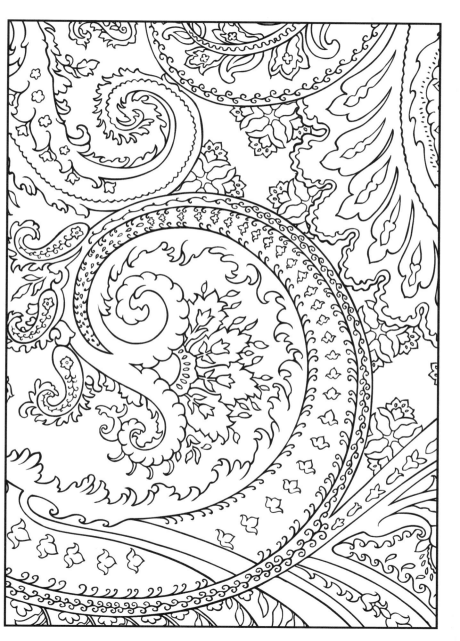

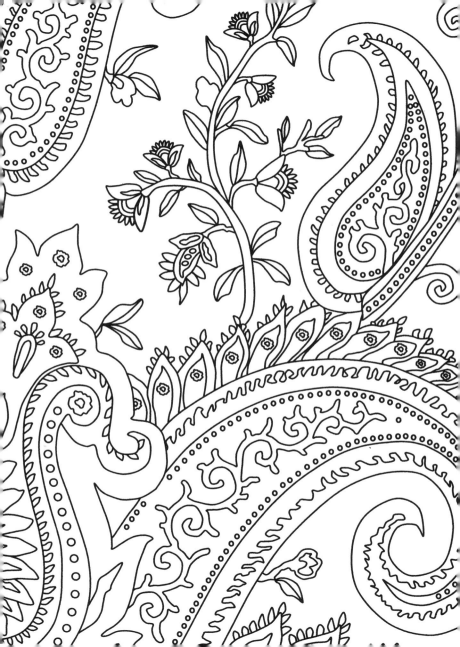

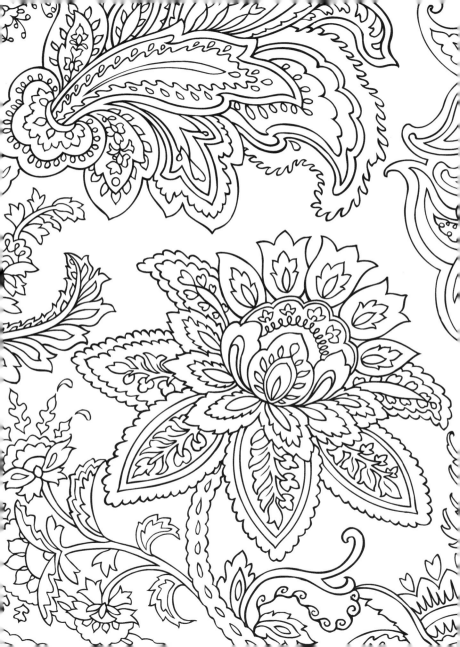

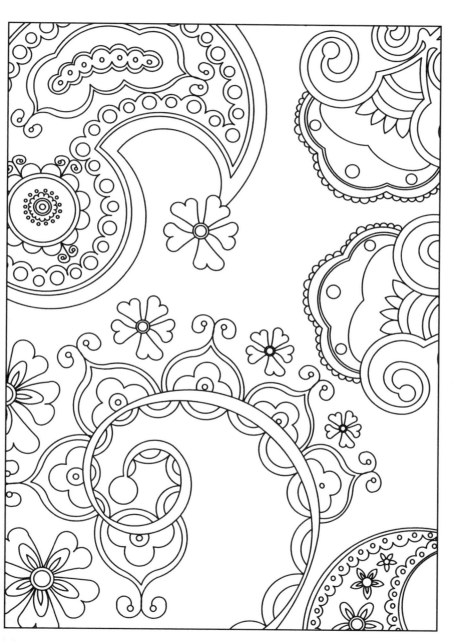

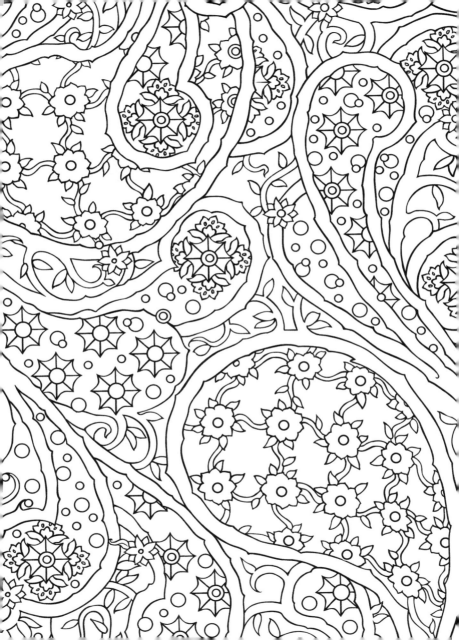

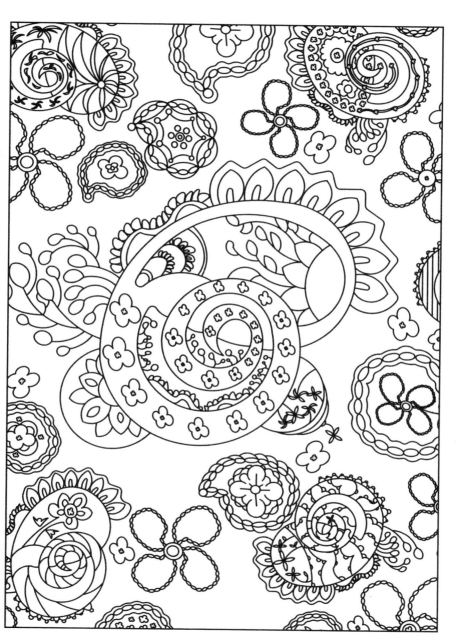

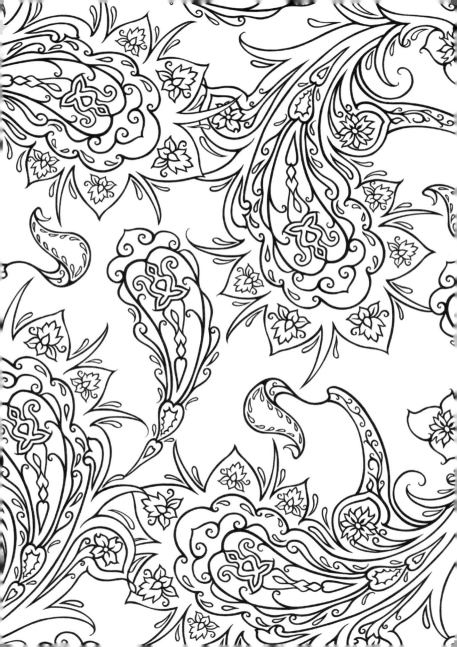

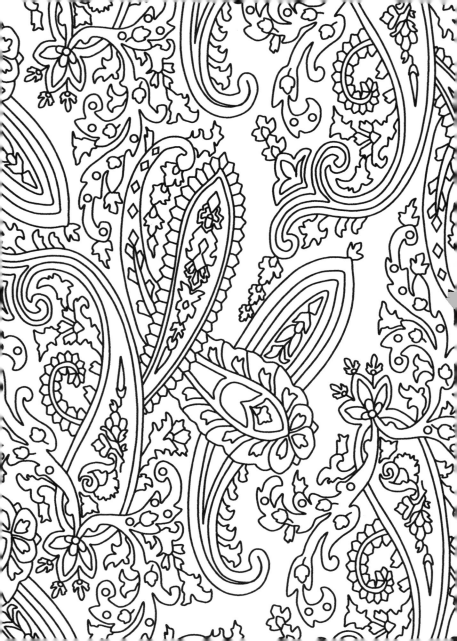

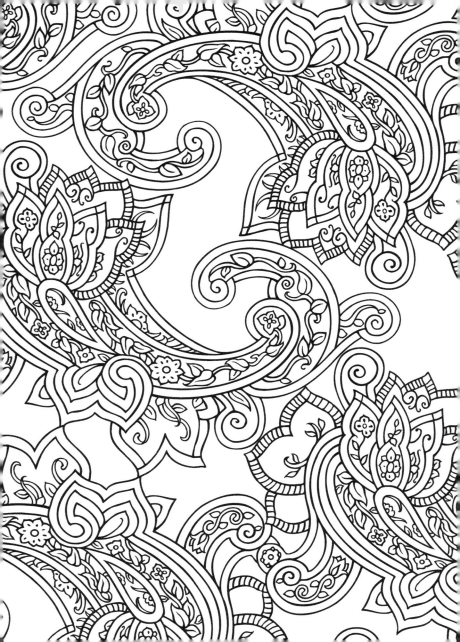

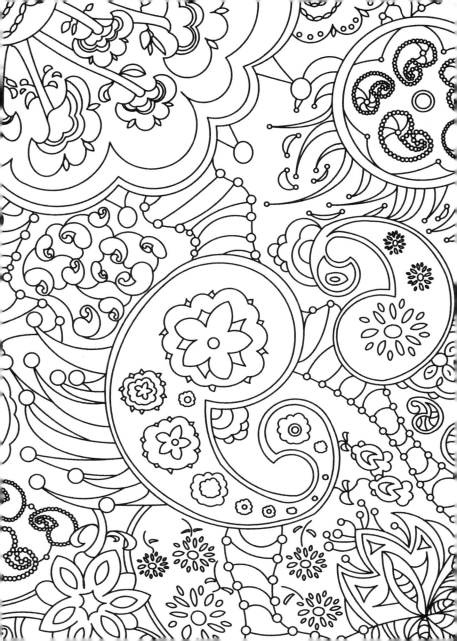

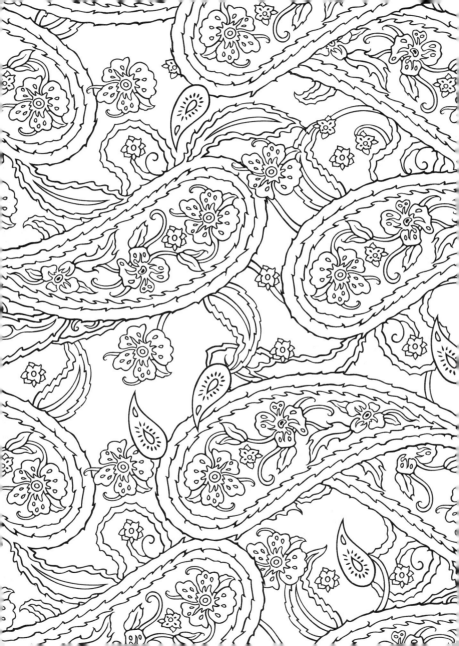

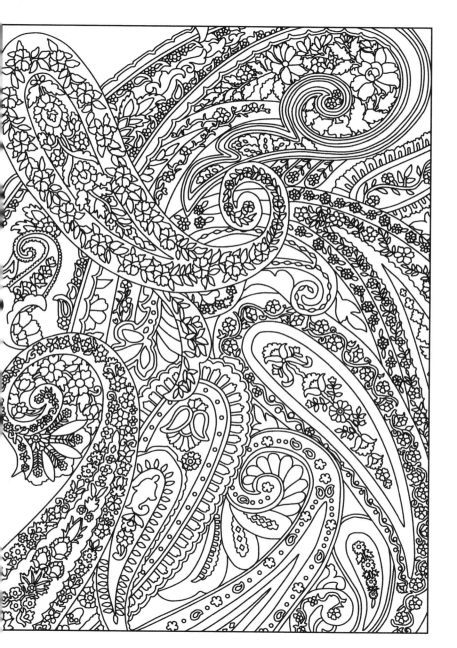

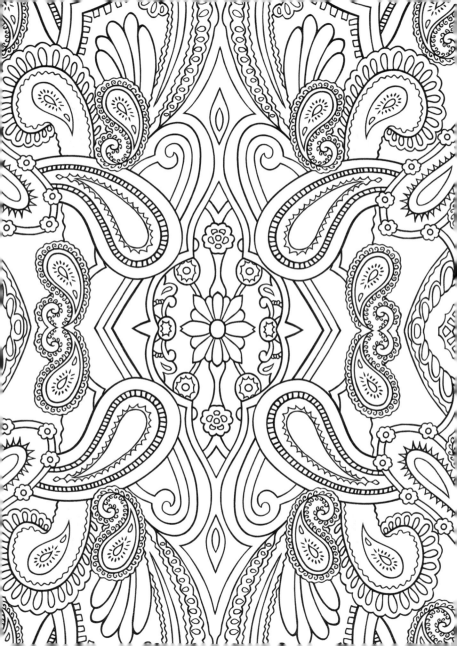

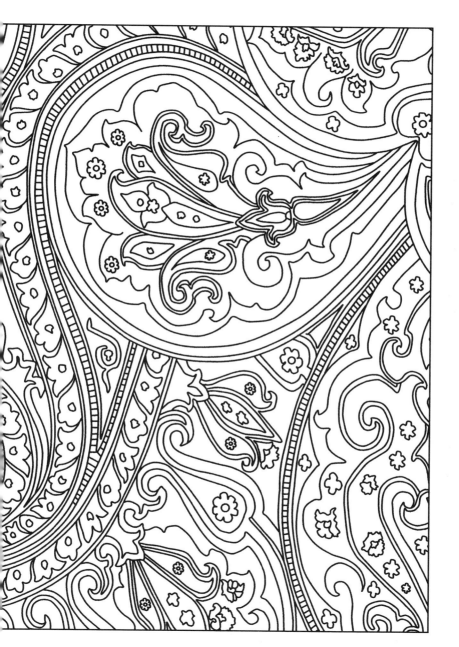

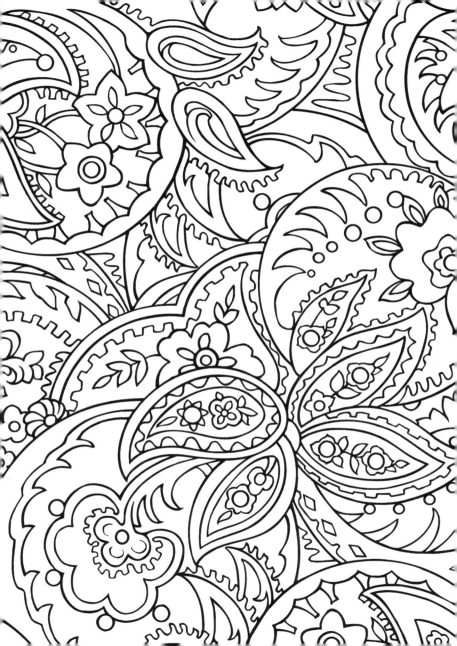